Water Mixab

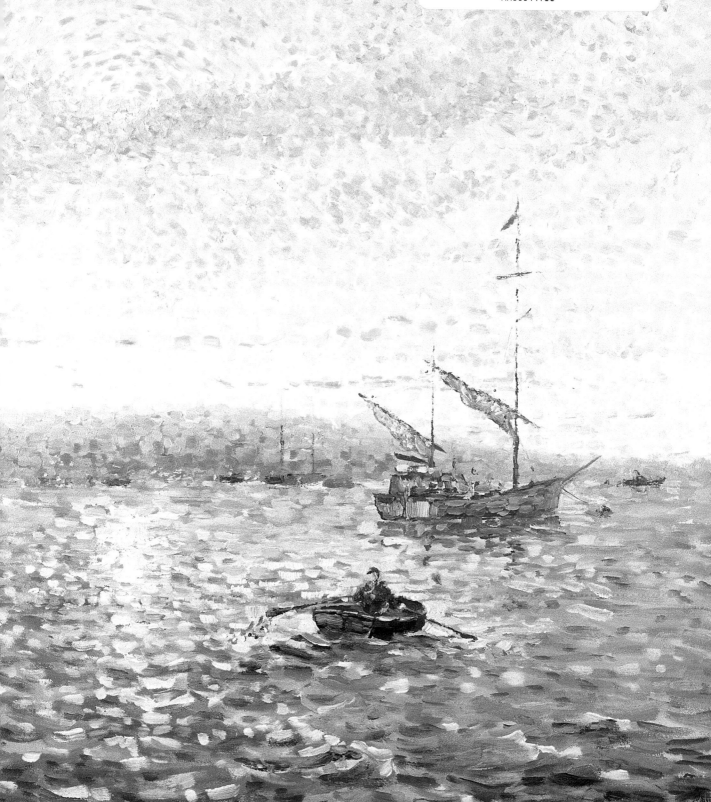

To the late Norma Beadle, who taught me that 'failure' is simply part of the learning process, mistakes are welcome lessons, and experimentation is essential to artistic development.

Water Mixable Oils

MICHAEL SANDERS

SEARCH PRESS

First published in Great Britain 2003

Search Press Limited
Wellwood, North Farm Road,
Tunbridge Wells, Kent TN2 3DR

Text copyright © Michael Sanders 2003

Photographs by Charlotte de la Bédoyère, Search Press Studios

Photographs and design copyright © Search Press Ltd. 2003

ISBN 0 85532 980 7

The Publishers and author can accept no responsibility for any
consequences arising from the information, advice or
instructions given in this publication.

The publishers would like to thank Winsor & Newton for
supplying many of the materials used in this book.

Suppliers
If you have difficulty in obtaining any of the materials and
equipment mentioned in this book, please visit the Search Press
website for details of suppliers: www.searchpress.com

Alternatively, you can write to the Publishers at the address
above, for a current list of stockists, including firms who operate
a mail-order service, or you can write to Winsor & Newton
requesting a list of distributors.

Winsor & Newton, UK Marketing
Whitefriars Avenue, Harrow,
Middlesex, HA3 5RH

Publishers' note All the step-by-step photographs in this
book feature the author, Michael Sanders, demonstrating his
oil painting techniques. No models have been used.

Printed in Spain by A. G. Elkar S. Coop. 48180 Loiu (Bizkaia)

*I would like to thank Chandy Rodgers for encouraging me to
write for* Paint *magazine, Sophie and Roz at Search Press for
their enthusiasm and advice, and all my students and fellow
artists, from whom I continue to learn. Last but not least,
thanks to Gwynneth for inspiration and support!*

Front cover
Cala de Deiá, Mallorca
Size: 280 x 204mm (11 x 8in)

*The beautiful blue of the shallow water inspired me to paint
this lovely little cove. A knife was used on the rocks and to
apply the verticals on the buildings and texture on the roofs. To
imply distance, the sea horizon was blended with a dry brush.*

Page 1
Catching the Tide
Size: 305 x 400mm (12 x 15¼in)

*This painting was inspired by the quiet evening stillness at the
mouth of the estuary. I have used a technique similar to
pointillism, where small strokes of colour are applied side by
side without blending.*

Pages 2–3
Upper Tamar Valley
Size 305 x 240mm (12 x 9½in)

*The soft effect of early morning has been captured by
blending the background and using pale, muted tones, with
minimum contrast.*

Opposite
Deiá, Mallorca
Size 280 x 204mm (11 x 8in)

*I wanted to paint the heat of this image, and chose a
complementary orange/blue colour combination to
capture the vibrancy. The background was brushed on,
the buildings applied by knife. A very rapid painting – it
took about twenty minutes!*

Contents

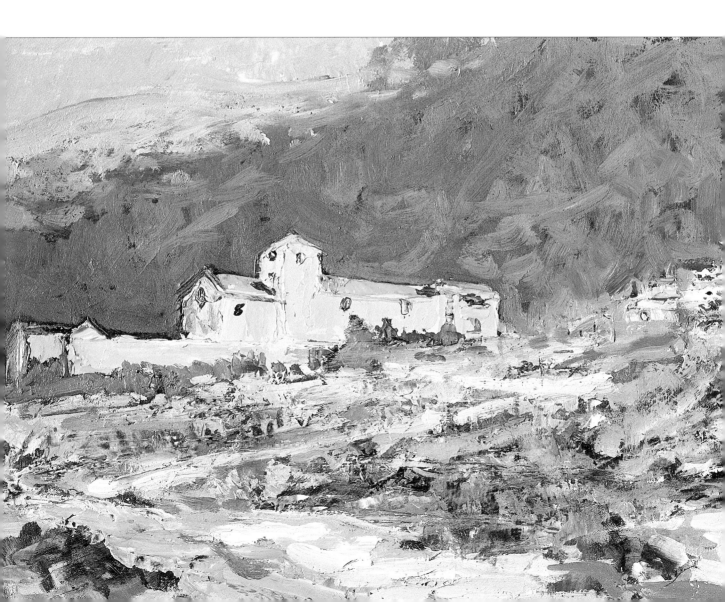

Introduction

I have been painting and teaching art for many years, and I am often asked, 'What is the best medium to get me started?' My answer used to be, 'Oil paint'. Now it is 'Water mixable oil paint'. I then explain how versatile the medium is, how easy to correct, fun to manipulate and adaptable to many styles and techniques.

In this book I describe and demonstrate most of the techniques available to the oil painter, the best choice of colours, brushes and mediums. What you won't find is any mention of turpentine or white spirit. This is because all of the paintings were produced using Winsor & Newton's Artisan, a genuine oil paint made with linseed or safflower oil, yet which can be thinned and cleaned up with water. When I first tried these, I could not believe they were not traditional oils, and brushes left in a jar of water virtually cleaned themselves! Since then I have used water mixable oils regularly, especially indoors. The advantages are obvious: no more smelly rags or bottles of spirit; just soap, water and paper towels.

All you need to paint with water mixable oils are a handful of colours, a piece of primed board or canvas, some brushes, jars of water and away you go. Because they dry at the same rate as other oils (not quickly like acrylics), you can take time to enjoy the painting process without worrying. Corrections can be made without panic and paint can be scratched through or scraped for interesting effects, or reapplied.

Most of the techniques I will show you are centuries old and have been used by many of the old masters. If you are using oils for the first time, start with the colour wheel on page 13: this will teach you about paint handling, application and blending, as well as colour. Follow me through a simple still life, then maybe paint a composition of your own, before moving on to more complex images. As you work through the examples in this book, your skills will improve and your confidence will grow. Some techniques will feel just right, some colours will appear more attractive than others. Gradually, with practice, your paintings will have a uniqueness that is yours alone. Be bold and never be afraid to experiment.

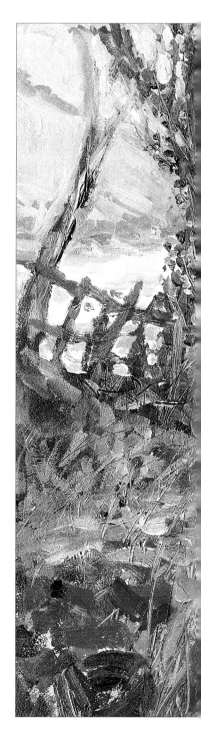

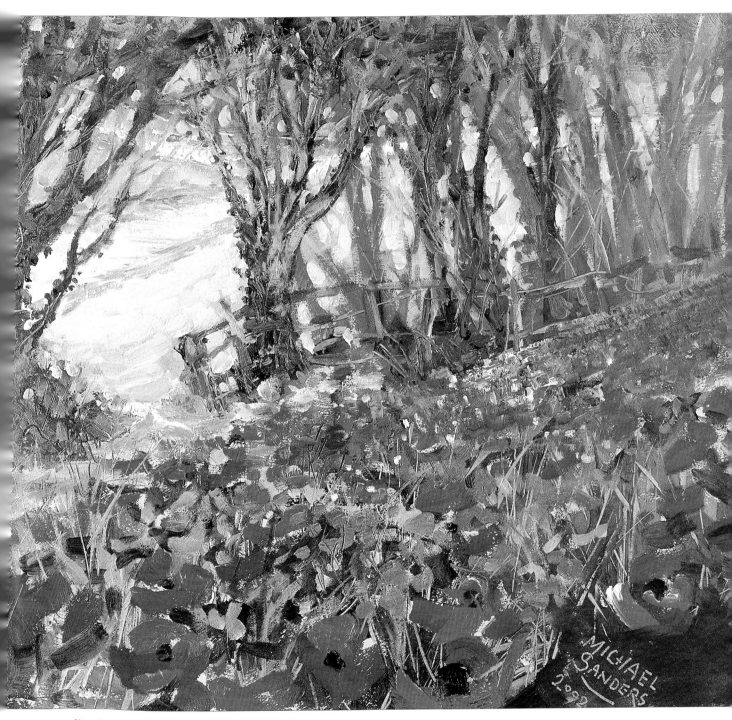

Woodland Poppies
Size: 490 x 330mm (19¼ x 13in)

*This painting relies heavily on careful use of tonal values,
as well as a harmonious range of colours.*

Materials

The range of water mixable oil colours is very extensive, but the good news is, you don't need them all in order to begin painting. In fact, by learning to produce colours by careful mixing, you will be adding to your skills as an artist, as well as saving money! Gradually as your colour sense grows and changes, you may feel drawn to a particular colour or combination of colours. Then you can make additions to this basic palette. To start with, though, keep it simple.

Paints

I have evolved this selection of colours over several years and it represents a minimum range, known as a limited palette. Working this way, with only ten tubes, makes our task of learning about colours and how they combine much easier. The primary colours, red, blue and yellow are represented by a warm variation and a cool one. To make a colour paler, white is added. There are three additional 'landscape' colours, favourites of mine, to make life easier. My water mixable oils palette consists of: lemon yellow (cool), cadmium yellow deep (warm), cadmium red light (warm), permanent rose (cool), French ultramarine (warmer), phthalo blue (cooler), titanium white (cool), and my landscape additions, all of which are warm: sap green, burnt sienna and Naples yellow.

My limited palette of water mixable oils. All the demonstrations in this book can be achieved using these colours.

Palettes

Any flat, non-absorbent surface can be used to hold and mix the paints: plastic, greaseproof paper, even glass. But nothing feels like a traditional artist's palette. For ease of use and comfort, the large kidney-shaped ones are best: if you are holding one for long periods of time you will soon appreciate its lightness and balance, and the warm, neutral tone of the wood makes colour judgement easier. I have several wooden palettes, including a folding one for use outdoors; I can close it with the paint still on it and carry it home to finish the painting in the studio.

Disposable paper palettes with tear-off sheets are particularly useful. When you have finished painting, tear the page off, fold it and throw it away.

Mediums

Water mixable oil paint is unique in its simplicity – you can paint successful pictures with just ten colours and water. As you become more experienced, however, you may find that some of the traditional 'old master' techniques intrigue you and you want to add mediums to your paint box. Some artists like to work layer by layer, slowly building up a painting and allowing each stage to dry before working on the next. If you would like to work in this way, you must use a medium to dilute your subsequent layers of paint. There are four types:

Water mixable linseed oil

This is a traditional oil painter's medium. It reduces consistency and improves the flow of paint, while increasing its gloss and transparency. It is very useful for making paint more workable if you are working on top of an oil painting that has been allowed to dry.

Stand oil

This thicker oil improves flow and is useful for the technique known as glazing. It is slow to dry.

Painting medium

This speeds the drying time slightly whilst increasing brilliance and transparency.

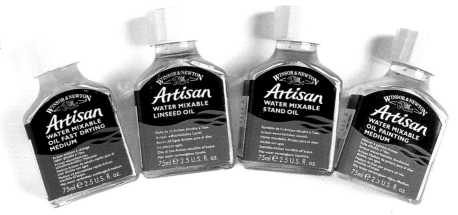

Fast-drying medium

This speeds the drying time quite dramatically and is excellent for fine wet on dry work (see page 16) and glazing.

Brushes and painting knives

Traditionally, hog hair was used for oil painting brushes but I prefer today's wonderful synthetic equivalents: they are longer lasting, easier to clean and keep their shape better.

Larger numbers denote bigger brushes. The size you choose will be governed by how 'big' you wish to work. Have a least two brushes that are larger than you think you will need, for blocking in large areas. The further you can progress with a painting using a large brush, the less tight and fiddly the result will be.

The shape falls into three groups: flat, round and filbert, and some come in short or long varieties of bristle. Flat is chisel-shaped with a square end, round is tapered, sometimes to a point, and a filbert starts out from the ferrule as a flat, then gently tapers. It is best to have a selection so that you can experiment and find your favourites. I prefer flat 4 and 8, long flat 2, 4 and 6, filbert 4, 5 and 6 and round 2 and 4. A fan blending brush is useful for moving paint around and smoothing areas, as well as for painting reflections and grasses.

Knives come in a variety of shapes and sizes. I prefer the ones with a bent handle, known as 'painting knives'. These can be used for mixing paint on the palette, scraping off mistakes and cleaning up. With a little practice you can learn to control knives and do a complete painting with them. I have two leaf-shaped knives: a large and a medium, and one tiny pointed one for detail.

Surfaces

Oil paint can be applied on almost any non-shiny surface: traditionally canvas and wood panels were used but hardboard, greyboard, cardboard, hessian sacking or brown paper have all been used. The main thing is to prime the surface well, so that the paint sits on it with good adhesion and doesn't sink in. I always use a good quality acrylic gesso for this, usually tinted with a little acrylic paint to give me a coloured background. You can buy canvas off a roll and make your own stretched canvasses, or buy them ready-made. You then need to tension them by tapping in the corner pieces with a small hammer, working diagonally. Canvas boards are also good: they are made from real canvas glued to a thick card to make a solid panel. You can also get some stiff cardboard or hardboard and prime it using acrylic gesso and a big brush.

I use an enamel plate to mix gesso with acrylic paint for priming surfaces, and an old household paintbrush to apply it.

Tapping in a corner piece to tension a ready-made stretched canvas.

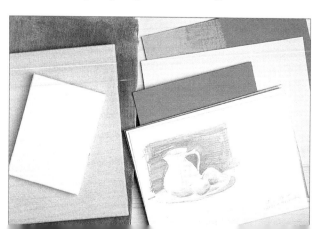

A variety of surfaces, some primed with tinted gesso, and a sketchbook.

Easels

To achieve success in oils you will have to step back periodically to assess your work and obtain an overview of the painting. Only by working at an easel will this be practical. The easel also holds the painting at the necessary near-vertical position. I prefer to work standing, so the easel needs to be high enough to avoid making me stoop. Whether you choose standing or sitting, make sure your working position is comfortable and does not induce aches and pains or cramp. A simple lightweight sketching easel in wood or alloy is fine, and it must be easily adjusted and stable. Sometimes when working outdoors I hang a bag full of stones from mine to stop it moving in the wind. A box easel with drawers for paints and brushes and a pull-out section to rest your palette on is marvellous but not essential. If you are not planning to work outside, a table-top easel will suit you very well, as long as it is adjustable for height.

All the demonstrations in this book were done at this table-top easel.

Other equipment

Before you begin painting, there are a few things you will need to make life easier. Pencils are of course invaluable for thumbnail sketches of compositions. The most important things once you start painting are paper towels or clean, lint-free rags. You need at least two water containers, one to hold water for dilution, one for cleaning brushes.

If you intend making your own boards and priming them yourself, a craft knife will be useful for trimming them to size. Sometimes I use masking tape around a board; when removed this gives a clean edge so that I can handle the painting before it dries. When you have finished painting for the day, a block of soap or a tub of brush soap will help to keep your brushes in good shape.

Understanding colour

Colour is a very personal thing but even a well-drawn, carefully composed image can be ruined by poor use of colour. Conversely, an indifferent composition can be enhanced by good use of colour. As artists, we should consider ourselves to be in complete control of what happens on our canvas and feel absolutely free to modify, or even change completely, the colours to suit our needs.

In general, composition and line give us the dynamics within a painting, tone gives us definition and logic and colour provides mood and emotion. If our colours clash or are dull, that is how our painting will affect the onlooker. So, in order to get the best results from our colours, we need to understand some of their properties.

To begin with, let's look at temperature. A colour can be described as warm, neutral or cool. This is one way of comparing one colour, or hue, with another. If you paint a small square with a cool yellow like lemon, then paint a similar-sized one next to it with a warm yellow such as cadmium yellow deep, the warm one will appear nearer to you than the cool one. Cool colours such as blues, blue-greens and violets appear to recede, and warm colours such as oranges, reds and browns appear nearer to you.

Next we can look at complementary colours, and to do that you need to make a colour wheel using six colours (two of each of the primary colours) plus titanium white.

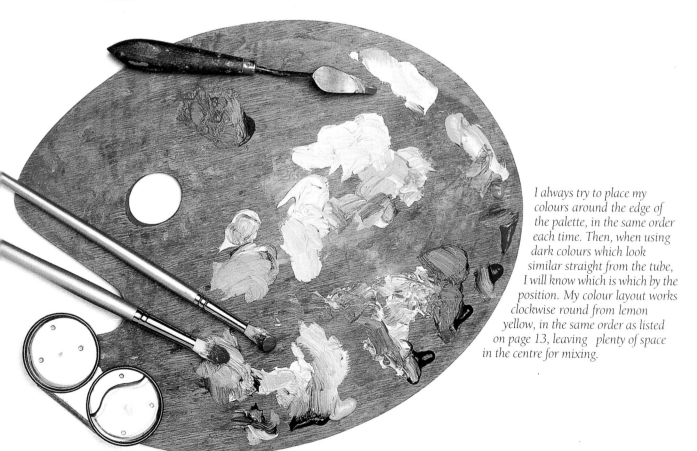

I always try to place my colours around the edge of the palette, in the same order each time. Then, when using dark colours which look similar straight from the tube, I will know which is which by the position. My colour layout works clockwise round from lemon yellow, in the same order as listed on page 13, leaving plenty of space in the centre for mixing.

Painting a colour wheel

Don't skip this exercise! When using paint that is unfamiliar to you, it helps to get the feel for it by making a colour wheel. You will learn how the paint blends, how you can scrape off a mistake and how the addition of white makes a tint. Keep the finished wheel for reference.

Oil paint is quite firm and buttery – marvellous for making textural marks. Don't dip into the paint to pick it up, instead scoop it up as if the brush were a spoon. Practise different strokes and textures to learn how it handles. Don't spread it too thinly – oil painting is about brush strokes and water mixable oils with their smooth consistency are great for creating strong texture.

Try to stick to the correct layout for the wheel: opposite the yellows should be purple, opposite the oranges should be blue, and opposite the reds should be green. These are termed complementaries, and used together as part of a composition, they will make your painting come alive. If a colour appears too bright and needs toning down, add a touch of its complementary colour: for instance, if a green is too bright, adding a touch of red will dull it down. To make a bright blue slightly greyish, add a little orange.

Now, let's get painting!

You will need

Greyboard primed with two coats of white acrylic gesso, or a canvas board

Disposable paper palette

Lemon yellow

Cadmium yellow deep

Cadmium red light

Permanent rose

French ultramarine

Phthalo blue

Titanium white

Three jars of clean water

Filbert no. 5 synthetic brush

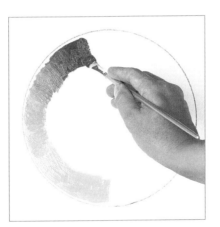

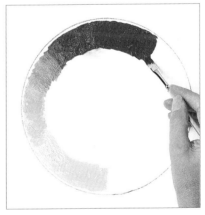

1. Draw round a plate to make the basic circle. Carefully apply lemon yellow using a no. 5 filbert brush. This is the most easily contaminated of all the colours, so make sure it does not touch the pencil line. The colour will go muddy or green if it meets the graphite.

2. Make a warmer yellow from cadmium yellow deep and lemon yellow. Add a tiny touch of cadmium red light to cadmium yellow deep to make a deeper orange. Paint on a postage stamp sized area of each colour, blending them into each other and ending up with pure cadmium red light.

3. Add permanent rose to cadmium red light to give a range of mid to dark reds. Permanent rose is quite transparent, so you need a lot of it to create a deep red. When you are painting pure permanent rose, make sure you wash your brush in water and wipe it on paper towel to remove all traces of cadmium red light before you apply it.

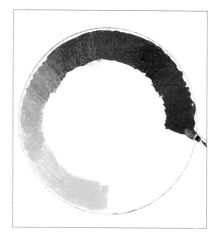

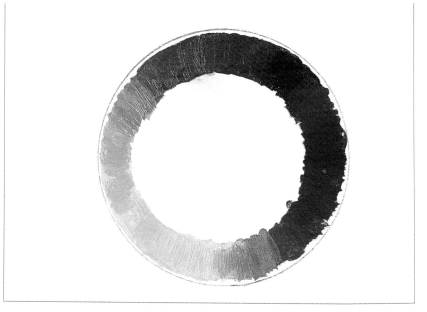

4. Mix titanium white with ultramarine and add this to permanent rose to make a plum colour. If this is too dark, you can add more titanium white. Add progressively more French ultramarine to the mix to make purple. If the colour gets muddy, clean it off and try again.

5. Wash your brush with clean water. Mix pure French ultramarine with a little titanium white to give a mid-blue. Next, mix in a tiny touch of phthalo blue – this is very strong but should produce a cooler, greenish blue. Mix in more phthalo blue, adding a little titanium white to stop the blue from getting too dark. Work towards neat phthalo blue. Add a tiny amount of lemon yellow to make a lovely turquoise green. Add more lemon yellow to the mix to get a sea green. Use the residue of phthalo blue in the brush to produce the rest of the greens. Leave a postage stamp sized area of the pure lemon yellow you started with.

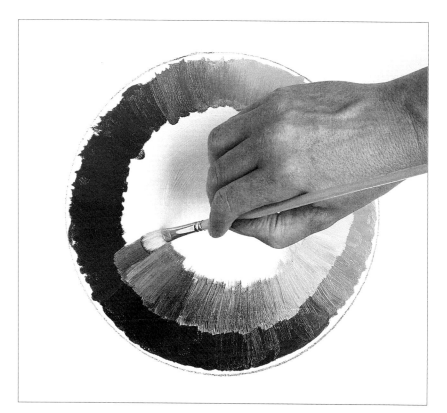

6. Using a clean brush, paint a disc of pure titanium white in the middle of the wheel, leaving a quarter of an inch all the way round. Be careful not to pick up any of the surrounding colours. If you do, wipe your brush immediately. Take a little touch of each colour, starting with lemon yellow and working clockwise, and drag each colour towards the middle, moving your brush strokes inwards over the edge of the white disc to produce a tint of each colour. After each section, wipe the brush with clean paper towel, using no water and squeezing the brush between your finger and thumb.

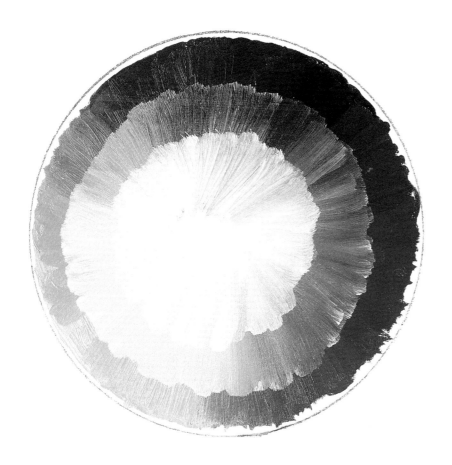

7. Clean the brush in water, dry it thoroughly on paper towel, and continue dragging colours in, starting with lemon yellow again, this time to the centre of the colour wheel. This will produce a range of paler tints. Leave a little white in the middle.

The finished colour wheel, made from a limited palette of just six basic colours, plus titanium white.

Blending other colours

The top row shows sap green, Naples yellow and burnt sienna, blended together in the same way as the colour wheel, producing a useful range of greens and browns.

 In the middle, an orange mixed from cadmium yellow deep and cadmium red light, with a little white, is blended with French ultramarine to produce some grey tints. Note that it is possible to do a nice composition using only two complementary colours like these.

 At the bottom, French ultramarine is mixed with burnt sienna to make a very dark grey. Titanium white is then progressively added, making a range of pale, warm greys.

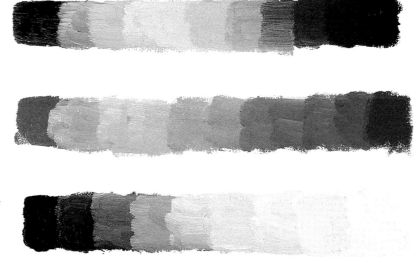

Techniques

Oils have the largest range of application techniques of all the art materials. Almost anything is possible. Due to its slow drying time and its viscous nature, oil paint can be applied with a roller, stamped, flicked, screen printed, sponged – even handprints and bicycle tyres have been used successfully to transfer paint to the image! Here are some of the more traditional methods, developed over centuries.

Wet on wet

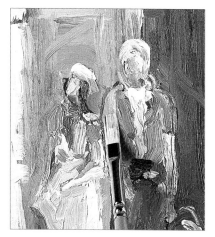

This is the simplest, most immediate technique. The paint is brushed on, usually to a coloured surface, allowing the underpainting to show through here and there and letting some blending take place. When applying strokes of light colour over darker tones, some unwanted mixing is likely to occur. To avoid this, wipe the brush in a paper towel after two or three strokes, re-charge it with paint and continue. Alla prima is the most spontaneous wet on wet method: working quickly, directly on to a plain canvas with little or no underpainting or drawing. All the step-by-step demonstrations in this book were painted wet on wet.

Wet on dry

A very traditional method, where the painting is allowed to dry between stages. The one cardinal rule in oil painting applies only to wet on dry and is usually referred to as 'fat over lean'. This means that when you are working over dried paint, the new paint must be diluted with a little oil or painting medium, not water. This is to ensure good adhesion between coats as the painting dries. Wet on dry techniques are often used in portraits, when progressively finer detail is applied. One to two weeks should be left between layers, so this method is not for the impatient.

Scumbling

This is a classic broken colour technique which can be applied wet on wet or wet on dry. Larger, flat brushes are best and some marvellous textural areas can be built up. Care needs to be taken to ensure that large changes in tone are kept to a minimum, or the effect can look clumsy. The method involves loosely brushing opaque, or even semi-transparent colour over other colours, allowing the colours underneath to show through and producing a brushed on 'painterly' look. Small strokes of colour that don't quite overlap can have a similar effect. This technique is very useful for foliage, trees, water (if the strokes are horizontal) and stormy skies.

Sgraffito

This is the scraping back of paint to show paint of a different colour or tone underneath. Any pointed object will do – you don't need to press too hard. I use brushes with their handles sharpened to a point, or wooden skewers. It helps if the underpainting is dry, which is why I recommend working on a tinted gesso primer. Scraping back to expose white canvas can also be very effective.

Blending

A fan blender is a brush made so that the bristles splay out in a V-shape. It is usually used not to apply paint but to soften an edge where the artist wants to show distance, or to create a graduation in colour such as in a sky. Wipe excess paint off between strokes, and use gentle pressure. A crosshatching motion gives the best effect, with the brush barely touching the surface.

Dry brush

In oils, in order to achieve broken highlights like sparkling water or the reflection on shiny hair, the white or pale colour must be applied on top. Hold the brush lightly, almost parallel and very close to the painting, and drag it gently across the surface. For subtle effects, use very little paint; for a stronger look, load the brush then remove a touch of paint on a paper towel, then apply.

Glazing

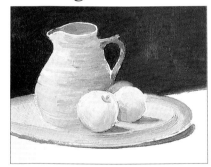 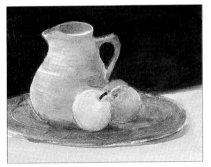

If you prefer a slow, methodical way of working, with several days between layers, this is for you. Building up an image wet on dry gives control and the ability to develop your work slowly, and glazing is the ultimate wet on dry technique. A glaze is best thought of as a transparent, coloured varnish. You should use fast drying medium, which allows three days or so between coats. Glazes can be used to modify parts of a painting that don't quite work. A red that is too strong, for instance, may be glazed over using a touch of its complementary, green. I mix my glazes in a white enamel plate. The white allows me to judge how strong my glaze is. It is best to start with a little medium, then add tiny amounts of the colour until the required pigmentation is reached. One fascinating technique using glazes involves making a monochrome painting in greys or browns, carefully considering the tonal values as you work. Then, when it is completely dry, the colour is added by glazing, allowing all the brush marks from the tonal study to show through, to create a lovely textural effect.

Knifework

The painting knife has always been used to apply touches of paint for highlights or to make linear marks. You can do a whole painting by knife, but be careful not to make the paint too thick. The technique of using heavy strokes of paint, whether by brush or knife, is known as impasto, and these impasto areas tend to look nearer than smooth ones, so use the technique for the middle distance and foreground. Start with an action like spreading butter on bread. The knife spreads more easily on its edge and works best when used wet on wet.

Still Life With Peppers

A still life like this is an excellent way to get started in oils. As you follow me through the steps, remember that this is a practical exercise, as much about paint mixing and handling as anything else. If you feel you have made a mistake, take a painting knife, scrape the area off and try again. If you find your colours are a bit too dark, introduce a little more white or Naples yellow. Throughout this exercise, try to make your brush strokes visible and let them follow the form of the object you are painting: curved strokes for the peppers and red onions, long strokes for the spring onions.

Before starting any painting, I suggest you take some thumbnail sketches like those below, with a pen or a 2B or 4B pencil. Try several views, using tone carefully and accurately, to see how things look from different angles. I chose the view ringed below for its unusual, downward viewpoint, and decided to cut off the left-hand side of the chopping board to allow the overhanging greens on the right more room.

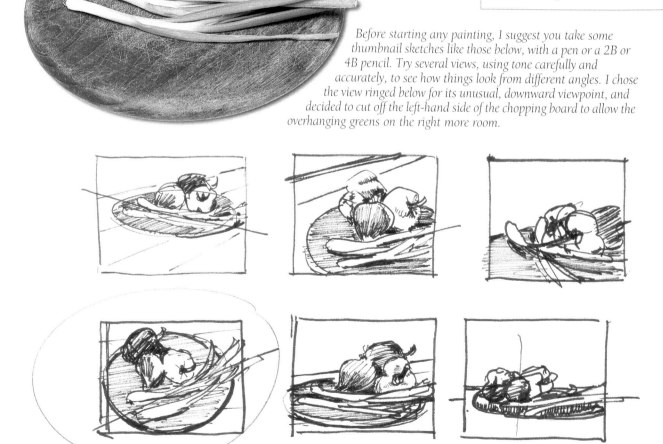

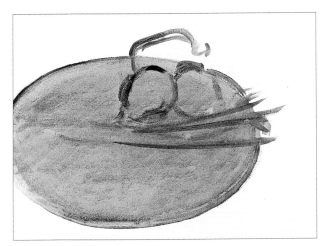

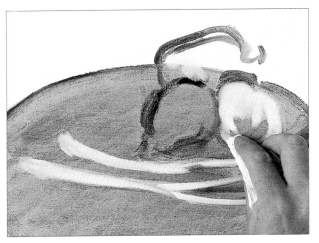

1. Block in the cutting board area using a short flat no. 8 brush and a mix of burnt sienna with a hint of cadmium yellow deep. Add ultramarine to make a darker colour, and sketch in the outlines using this mix, diluted slightly with water.

2. Use a lint-free rag or a paper towel dampened with a little water to wipe out the areas that are going to be pale.

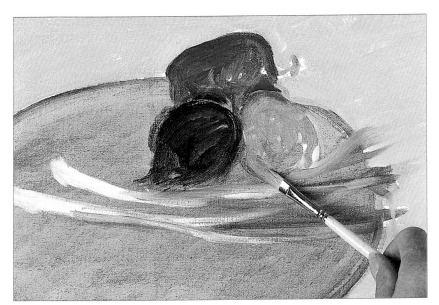

3. Block in the background using a no. 8 flat brush and a dilute mix of Naples yellow with a hint of French ultramarine. Change to a no. 6 filbert and paint in the orange pepper with cadmium yellow deep and a touch of cadmium red light, diluted with water. Use sap green and burnt sienna, diluted, for the green pepper. Paint the spring onion leaves with the same mix, but with a little lemon yellow added. Brush the paint on quickly with no attempt at adding detail. Paint the red onion using permanent rose, French ultramarine and a little burnt sienna, diluted.

4. Block in the background with more solid colours: Naples yellow with a hint of ultramarine, and a touch more blue in the distance at the top to make it look as though it is receding. Deepen the tone of the chopping board using a mix of burnt sienna, cadmium yellow deep and Naples yellow.

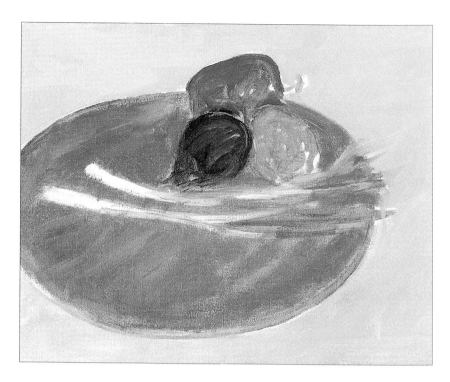

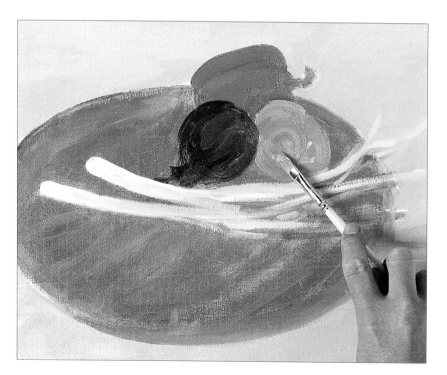

5. Using a no. 6 filbert, block in the mid-tones (somewhere between the darkest and the lightest) of the vegetables, using mixes similar to those used before but almost undiluted. Allow little touches of the underpainting to show through and make the shape of the brush strokes follow the form of each vegetable. Using burnt sienna and a little Naples yellow, carefully indicate the shadow around the right-hand edge of the board.

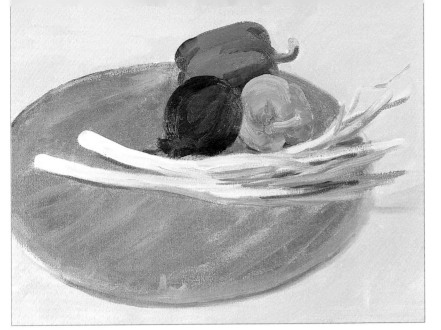

6. A darker colour now needs to be applied to each of the vegetables on its shadow side. The dark for the green pepper is mixed using sap green, a little French ultramarine and a touch of white so that it is not too dark, then carefully painted using a no. 6 filbert. Do not use paint too sparingly, and do not dilute it, since water mixable oil looks great if the brush strokes are allowed to show texturally. Clean and dry the brush, then darken the shadow side of the red onion using permanent rose, burnt sienna and a tiny touch of French ultramarine. Mix cadmium yellow deep with a touch of cadmium red light and a little burnt sienna. Using a clean brush, add touches of this deep orange to the right-hand side and the centre of the pepper. Sap green and lemon yellow are used for the dark areas of the spring onions, and for the stalk on the orange pepper. Finally, a purple grey shadow made from French ultramarine, permanent rose and Naples yellow is painted around the bottom right-hand edge of the board with a no. 2 long flat brush.

7. Add a hint of titanium white to each vegetable colour mix, and use a no. 2 long flat brush to add highlights to the vegetables.

8. Use a stick or the handle of a paintbrush and the sgraffito technique to scrape out the roots of the spring onions and the red onion. Wipe excess paint from the stick regularly.

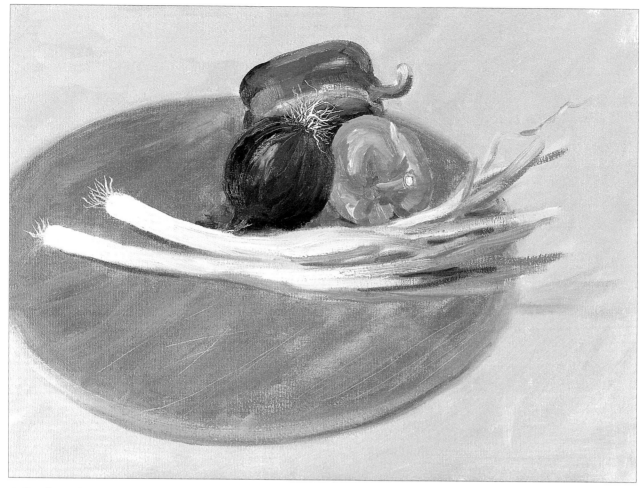

Still Life With Peppers
Size: 400 x 300mm (15¾ x 11¾in)

The finished painting. This is a good, simple composition using the traditional oil painting method of blocking in large areas with a large brush and dilute paint, then working with stiffer, less diluted paint. Smaller brushes were used to establish the middle tones of each colour, then the darks, and finally the highlights were applied using a small brush.

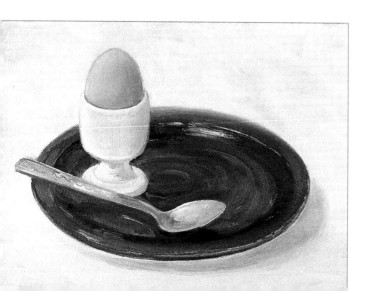

Breakfast
260 x 180mm (10¼ x 7in)

The beauty of painting a still life is that you don't have to look far to find a subject! I particularly wanted to show the ridges on the hand-thrown plate here, and reflections of the spoon. This contrasts well with the soft background.

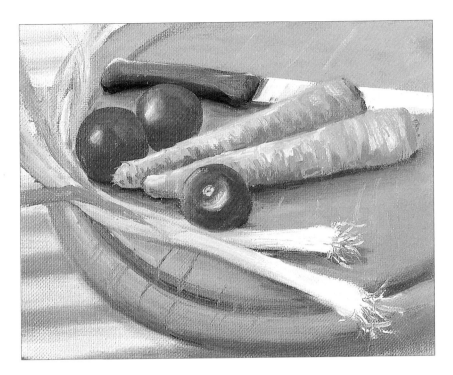

Still Life With Vegetables
Size: 300 x 240mm (11¼ x 9½in)

Vegetables found in every kitchen make excellent subjects on which to practise your techniques. This simple composition relies heavily on a complementary red/green colour combination, with the blue stripes adding some essential coolness.

Citrus
Size: 300 x 240mm (11¼ x 9½in)

Although this painting looks deceptively simple, it needed careful handling of the tonal values to make it work. The shading around the foreground lemon section and the relative paleness of the piece behind, creates a three-dimensional impression. Background edges have been blurred with a fan blender to imply distance. Highlights on the lemon squeezer were added using a knife.

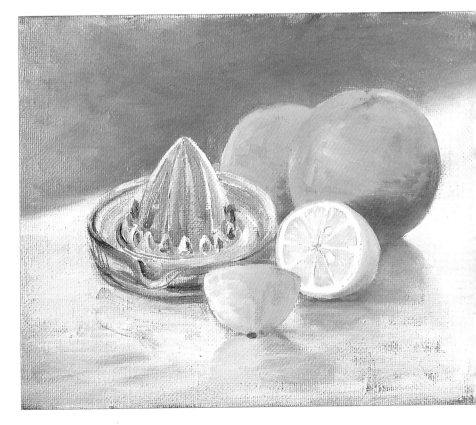

Flowers in the Landscape

My inspiration for this painting came initially from the colours of these marigolds and the contrast between the dark greens at the bottom of the image and the blueish tinges visible at the top. I decided to allow the composition more space at the top and, using the blaze of marigolds as a focus, I wanted a complementary colour scheme which included plenty of blues. This gave me the idea of inventing a simple, blue-based landscape that would fit in the top third of my composition but which would not contain much in the way of detail – with a distant sea.

When combining flowers and landscapes, one of the elements must be dominant. You have to decide whether you are painting a landscape which has flowers in it or a flower scene with a simple landscape as a backdrop. You cannot have both, or the painting will become too busy.

You will need

Board primed with acrylic
 gesso tinted with acrylic
 burnt sienna
Sap green
Burnt sienna
French ultramarine
Phthalo blue
Titanium white
Lemon yellow
Naples yellow
Cadmium yellow deep
Cadmium red light
Small painting knife
Paper towel
Brushes:
 No. 5 filbert
 No. 4 filbert
 Round no. 4 synthetic

The reference photograph

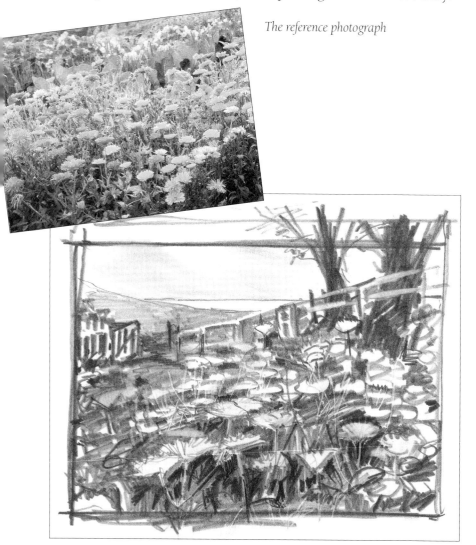

My initial sketch. The flowers are drawn tonally, as if from a lower viewpoint and more in 'close-up' than in the reference photograph. I have added a pale fence with a gate on the left as a natural break between foreground and distance. The trees were put in to give a little interest in the sky area, and the horizontal line of the sea was drawn across as a foil to the diagonal of the fence. Having completed this sketch, I made a mental note to leave the gate out as it looked distracting, and to lean the trees into the painting, rather than out.

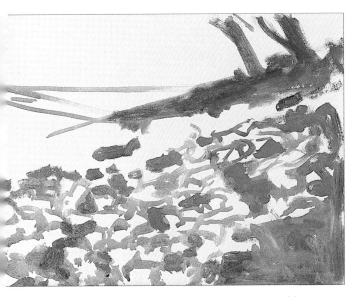

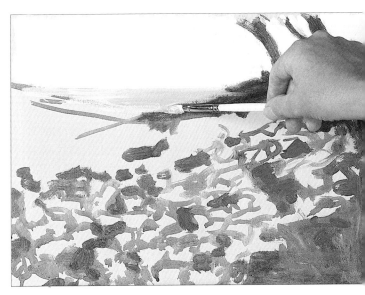

1. For the initial sketch, mix sap green and burnt sienna, and thin the mixture with water, to the consistency of condensed milk. Using a no. 5 filbert bristle brush, block in the basic shapes, leaving holes for the flower heads. As the painting recedes into the distance, cool the mix with ultramarine.

2. Block in the sky using ultramarine made greyish with a touch of burnt sienna. The mix should be thinned with a hint of water – enough to make it flow nicely. Use a vigorous brush action and keep your painting loose. Paint the sea with a hint of phthalo blue, titanium white and a little lemon yellow. Allow the background colour to show through, creating highlights on the water.

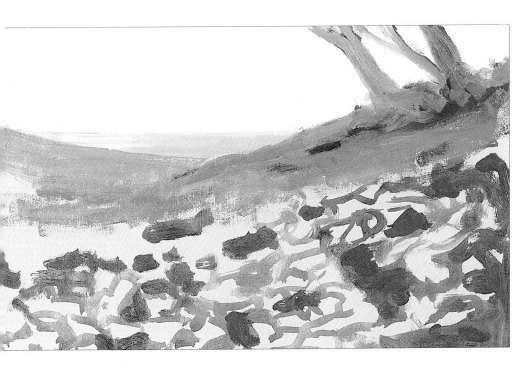

3. Block in the distant hills using a bluish-green mix of ultramarine with a little lemon yellow and titanium white. Use vigorous brush strokes. Mix burnt sienna with ultramarine and white to make a bluish grey, and paint over the background green of the sketched trees. Paint some of the background foliage using the same mix with a hint of sap green to make a distant blue-green.

4. Use a small painting knife and the sgraffito technique to scratch out foliage in amongst the flowers. The colour of the board will show through. Join some of the lines to the flowers to create stalks. Use the flat of the knife to paint broader leaves in the foreground.

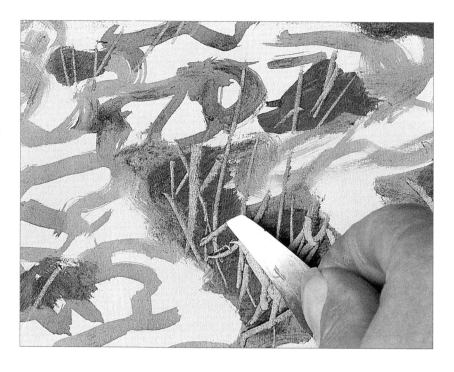

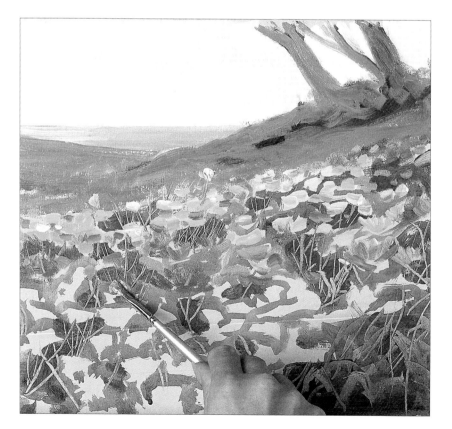

5. Paint the basic shapes of the blooms in the background in a dull orange mixed from cadmium yellow deep and cadmium red light, using a no. 4 filbert brush. Vary the colour mix to create a natural look. For the most distant flowers, add a hint of pale ultramarine. Paint in patches of flowers rather than individual flowers or petals – the detail will be added later using tone.

As you come towards the foreground, add a warmer orange. If you find that you are painting regular patterns, make sure you break these up to retain the random look of nature. If you have painted large areas of one colour, break this up with another shade.

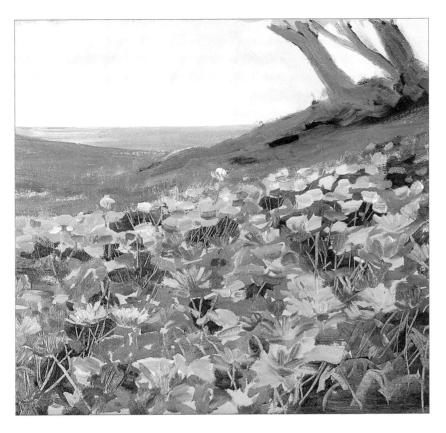

6. Block in the foreground blooms, the orange ones first. Use the sgraffito technique and the wrong end of a paintbrush to scratch out the shapes of petals. Some of the flowers are viewed from behind, so scratch out the shape where the stalk joins the flower. In the very foreground, apply paint freely to imply petals – do not make any very definite shapes, or these will draw the eye to them. Lastly, mix lemon yellow and white with a little water for the more yellow flowers. Be careful not to contaminate the yellow with the background green – you will need to wipe your brush occasionally with dry paper towel.

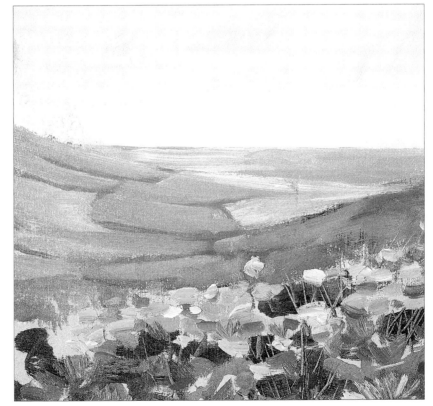

7. Make a pale green from Naples yellow, lemon yellow and a hint of phthalo blue. Paint it on to the distant hill on the left, making it lighter in tone than the sea. Stroke across, using a no. 4 filbert, leaving gaps to give the impression of hedges. Don't make the shape of the fields too square and regimented. Wipe your brush periodically. Vary the colour of the fields by adding more or less Naples yellow. Nearer to the foreground use warm green with a little burnt sienna.

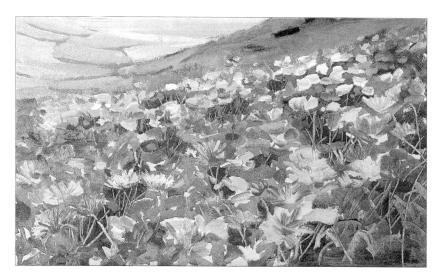

8. Mix a pale blue-green from phthalo blue, sap green and Naples yellow, and paint around the distant blooms to define their shapes. Don't add too many sharp edges. Go over the whole flower area adding definition and tidying up. I have painted out a bloom at the back, because it was too dominant and too central.

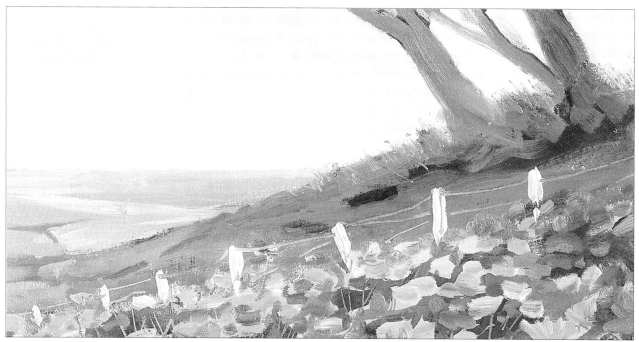

9. Mix titanium white and a hint of Naples yellow and paint in the fence posts, which lead the eye downwards to create the effect of distance. Sgraffito with the end of a brush to scratch in the wire of the fence, and to roughen the skyline beneath the trees to suggest foliage.

Add darks to the foreground with sap green, phthalo blue and Naples yellow, and sgraffito stalks and leaves. Use a little burnt sienna to warm up the foreground, and to define the petals on the nearest flowers. Paint inwards towards the flower centres. Some flowers should be anchored to the ground with dark stalks. Add darks under the foreground blooms to give them form. The foreground of this painting should be darker and warmer than the middle or background.

10. Use a round no. 4 synthetic brush and a mix of cadmium yellow deep and titanium white to paint highlights on the left-hand side of some of the flowers, to show the direction of the sun. Pick out petals in very light colours.

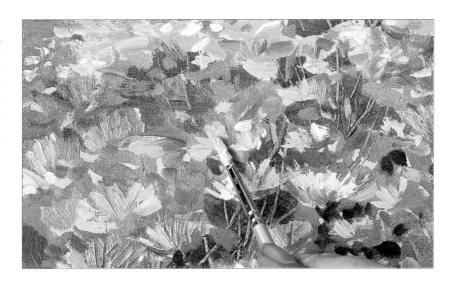

Flowers in the Landscape

Size: 410 x 310mm (16 x 12¼in)

The finished painting. In the final stage, I have lightened and warmed the trees with burnt sienna, ultramarine and Naples yellow, which make a soft, pale grey. The effect is to soften the trees and make them fade into the background. I have also painted and highlighted additional branches. I took a fan blender and blended across the horizon to soften it, then did the same with the sky.

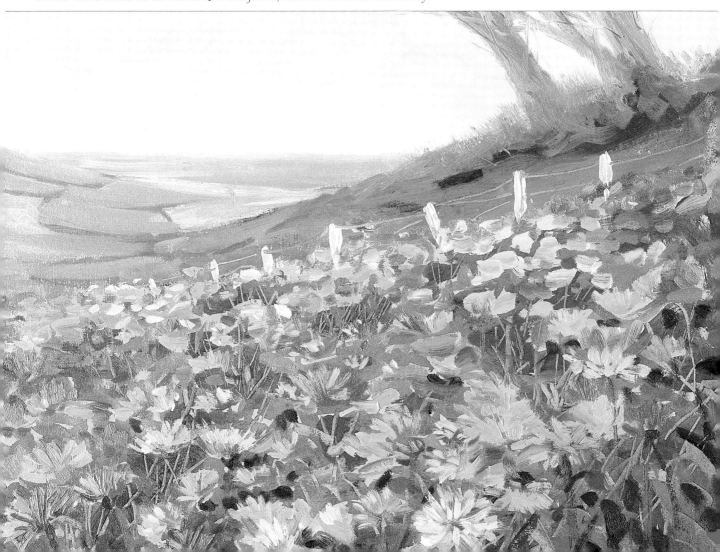

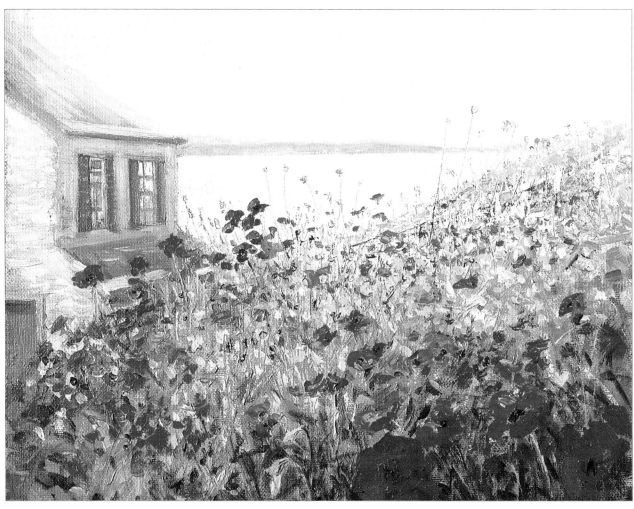

Coastal Poppies
Size: 300 x 240mm (11¾ x 9½in)

The still, quiet background makes the perfect foil for the dancing poppies, and the house on the left adds some solidity and vertical movement. The red-green combination in the foreground works well to 'anchor' the composition.

Tamar Daffodils
405 x 510mm (16 x 20in)

In Cornwall, where I live, the hedgerows in the spring are filled with daffodils of all shapes and sizes. They can be white, yellow, orange or any combination. For me, the coming of the daffodils means an end to winter and the start of spring. In this composition, the blooms have been placed against a dark background in order to enhance their colour, while the distant, wintery trees were painted purple-grey to complement the yellows. I've used single, isolated strokes of colour in the background to give a soft, shimmery effect. The foreground leaves were scraped back with a painting knife and the distant cottages were made in the same way. The red sail was added some months later, making sure some medium was mixed with the paint, wet on dry (see page 16).

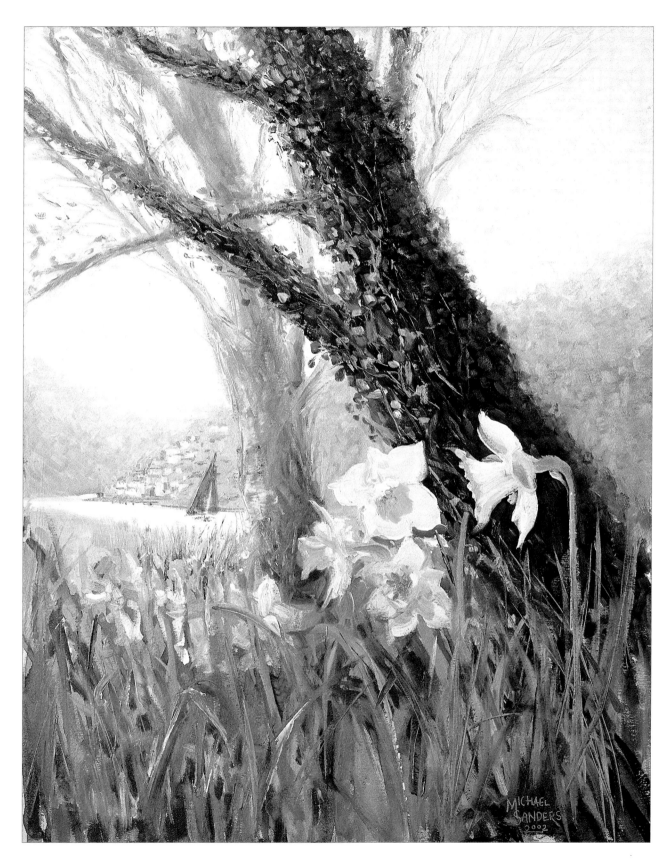

Willy Lott's House

This project consists of a building in the landscape, which is bound to introduce the dreaded 'p' word: perspective. In the simplest sense, perspective means looking at a line and observing if it slopes. If so, is it nearly horizontal or nearly vertical, or somewhere in between? In order to draw or paint a building that we can actually see, that is all we need to know. Look at a line and see if it slopes down to the left or down to the right. The following exercise will help:

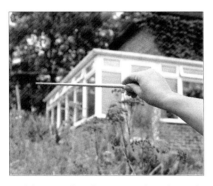
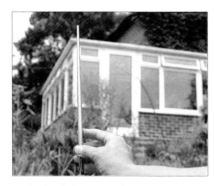

Hold a paintbrush at arm's length, so that it is absolutely horizontal. Close one eye and, keeping the brush level, move your arm so that the line you want to observe (a roof apex, gutter, pavement etc.) is behind the brush. Compare the line with your horizontal. On your drawing, make a faint horizontal guideline and reproduce the angle you observed, taking care to slope it the same way. If a line is nearer to vertical than horizontal, hold your brush vertically and compare the line with this. Continue with other lines until you have transferred everything to your sketch.

For this painting I stood in exactly the spot where Constable painted, took some photographs and made some sketches.

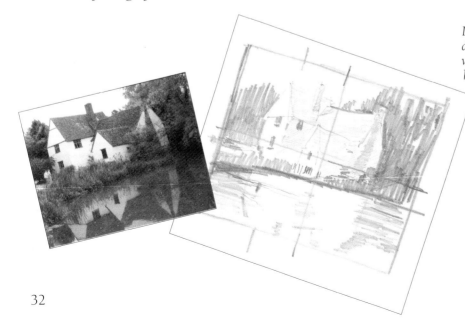

I always like to make some preparatory drawings in order to establish the tones: where the darkest areas are, where the highlights should be and so on. To make transferring the image easier, I divided both the sketch and the canvas into quarters, then concentrated on one quarter at a time.

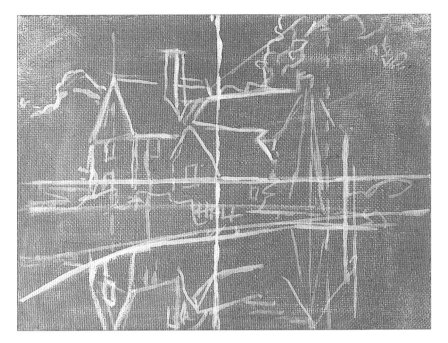

1. Before beginning, I primed a stretched canvas with acrylic gesso tinted with green acrylic paint, then left this to dry. It is nice to work on a dark canvas: it is as if the mid-tones are already there. Once you have established the shapes and blocked in the sky, the image seems to take shape quite quickly.

Sketch the outlines of the scene in dilute Naples yellow, including the lines that divide the picture into four.

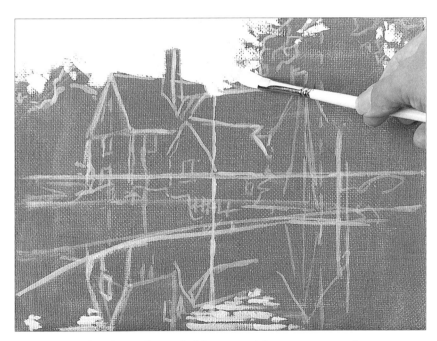

2. Block in the sky with a pale blue mixed from titanium white, ultramarine and a tiny bit of phthalo blue, all straight from the tube for good opacity. Use a no. 6 filbert brush. Leave holes for the trees, and paint skyholes in the trees – they can be adjusted later. Add a bit more ultramarine and a hint of permanent rose to paint the sky's reflection, which should be darker and warmer than the sky. Paint with horizontal strokes to create the effect of water.

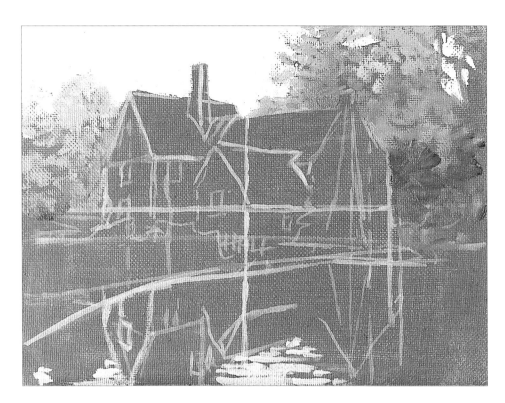

3. Block in the lighter areas of green on the trees using sap green mixed sometimes with Naples yellow and sometimes with burnt sienna, to create variety. Leave the background showing for the darker areas.

4. Paint the reflections of the trees using the same colour but with a touch of ultramarine and a tiny bit of burnt sienna. Start blocking in the reeds with phthalo blue, sap green and Naples yellow. Use rough brush strokes. Shade the base of the reeds using a darker version of this mix, with more blue added.

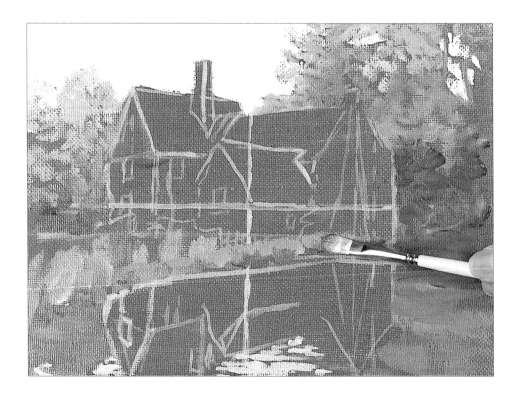

5. Block in the shadows on the right-hand side of the house walls using permanent rose and Naples yellow with plenty of titanium white. This makes a very pale, purply grey. Leave gaps for the dark fence posts. Leave the windows unpainted. Add a little pale ultramarine to modify the parts where the shade is greatest, under the trees and at the bottom of the building. Make a slightly darker version of this colour, adding more ultramarine and Naples yellow, for the reflection. Make sure the reflection is directly below the object reflected, and make wavy lines at its edge to imply movement on the water.

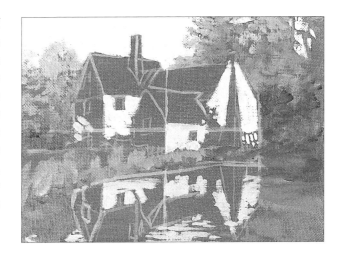

> **Note** At this point in the painting, I decided to remove the fence, which wasn't working, and replaced it with brickwork.

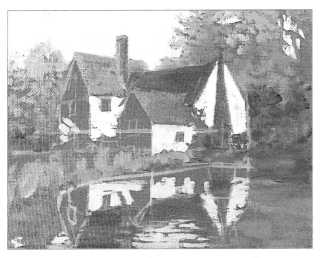

6. Mix permanent rose, burnt sienna, Naples yellow and white for the roof. Allow the background to show through to give the impression of texture, and don't make the lines too straight: curves give an authentic rustic look. Add a purple made from ultramarine and permanent rose for the top of the right-hand ridge and the chimney on the right-hand wall, also for the shadowed side of the left-hand chimney. Paint the reflection of the roof with the same purply brown, using horizontal strokes and creating a rippled edge.

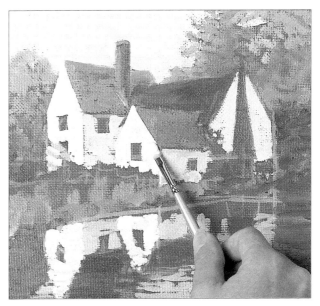

7. Clean your brush and dry it thoroughly to keep the paint full strength for the lightest tones of the house. Mix a cream from titanium white with a hint of Naples yellow and lemon yellow. Paint the sunlit areas of the house, and then darken the mix to paint their reflection.

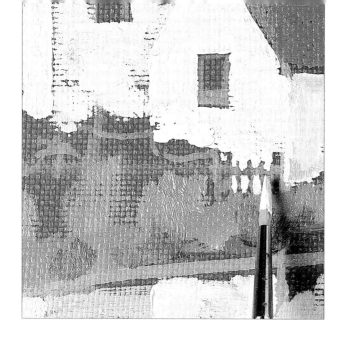

8. Paint the holes in the gate with a no. 4 round brush, leaving the dark posts as background colour.

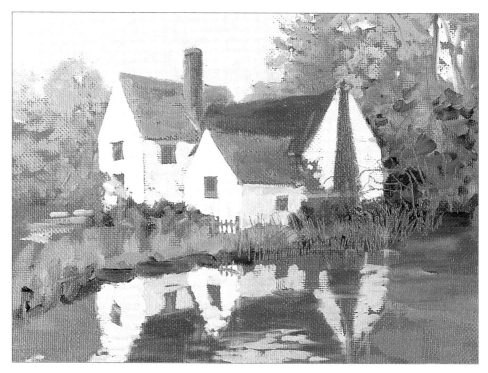

9. Use a flat no. 4 brush to add the darks to the foliage area on the right-hand side of the picture and the riverbank with a mix of sap green and burnt sienna. Continue adding darks around the bases of trees, and define the shapes at the bottom of the foliage. On the right-hand side, blend away the waterline with horizontal strokes of an almost dry brush. Darken the area along the water's edge. Paint in the brownish green tree on the left of the background, with burnt sienna, sap green and a hint of Naples yellow. Use a hint of Naples yellow and burnt sienna for the pathway on the left. Don't take it to the edge or it will draw the eye out of the painting. Sgraffito the branches on the right-hand side of the house and foliage in front of it, as well as the reflection of the gate.

10. Apply lemon yellow, sap green and Naples yellow to the rushes to reduce the strength of the greens and to soften the edges. Use a no. 2 round brush and a purply green made from ultramarine, permanent rose and Naples yellow for the window details. Mix burnt sienna and ultramarine and paint the dark areas of the roof and chimney. Paint the lightest parts last: mix an orange from Naples yellow, cadmium yellow deep and cadmium red light and paint highlights on the ridge tiles of the roof and on individual tiles. Subdue the same orange with a touch of burnt sienna to paint the highlights in the reflection.

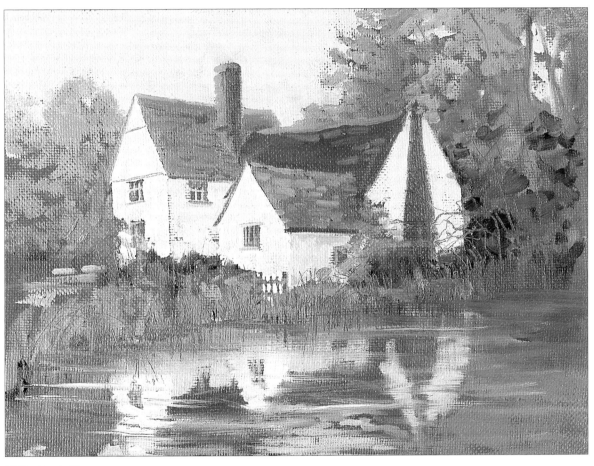

Willy Lott's House
Size: 300 x 240mm (11¾ x 9½in)

When the main work of the painting is done, stand well back from it and ask yourself these questions: Does anything appear to jump out at you – and should it? Is the overall image a little dull? If so, where should your highlights go? Is the sky too dark? Do the tonal values work, i.e. if things are supposed to contrast, do they? Are the darks dark enough? Like me, you will have some adjustments to make. Make these changes swiftly with a small brush, standing back after each one to view the image as it is modified. In this painting I used a fan blender to soften the reeds going down into the reflection, and to put ripples in the water with horizontal strokes. I used the sgraffito technique to define the architectural details of the house and to define the waterline. Finally I used white with a hint of blue on the edge of a painting knife to create highlights in the water.

If some part of your painting is really wrong, leave it and come back to it later! If it still looks wrong, take a knife, scrape off the offending area and re-work it. All the great artists from Holbein to Hockney have corrected, adjusted and adapted their work in this way.

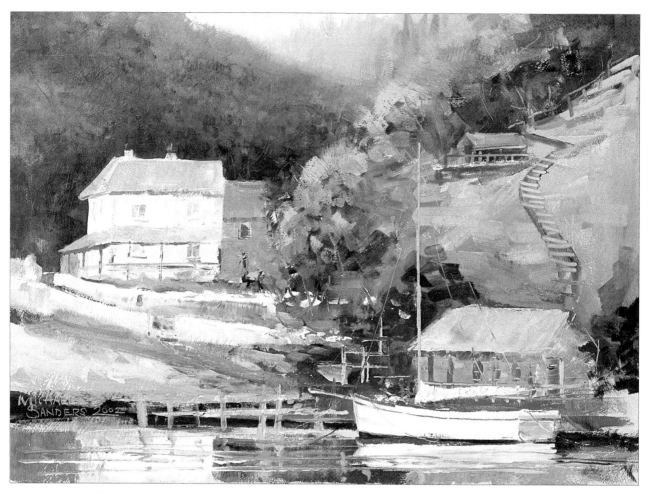

Danescombe Valley
Size: 410 x 280mm (16¼ x 11in)

The jetty and foreshore buildings, which were quite complicated, needed a lot of simplifying. Most of this painting was done with a large knife, with brushes being used to soften the occasional edge, especially in the distance.

Polperro – Tying Up
Size: 350 x 440mm (13¾ x 17¼in)

This painting is an example of a small touch of colour that needs to be exactly the right hue. The water at the bottom of the steps is dark blue-green, so the complementary, orange-red, is the only colour for the round float. It just would not work with any other colour, and this touch really livens up the painting. Cover it with your finger and see what I mean!

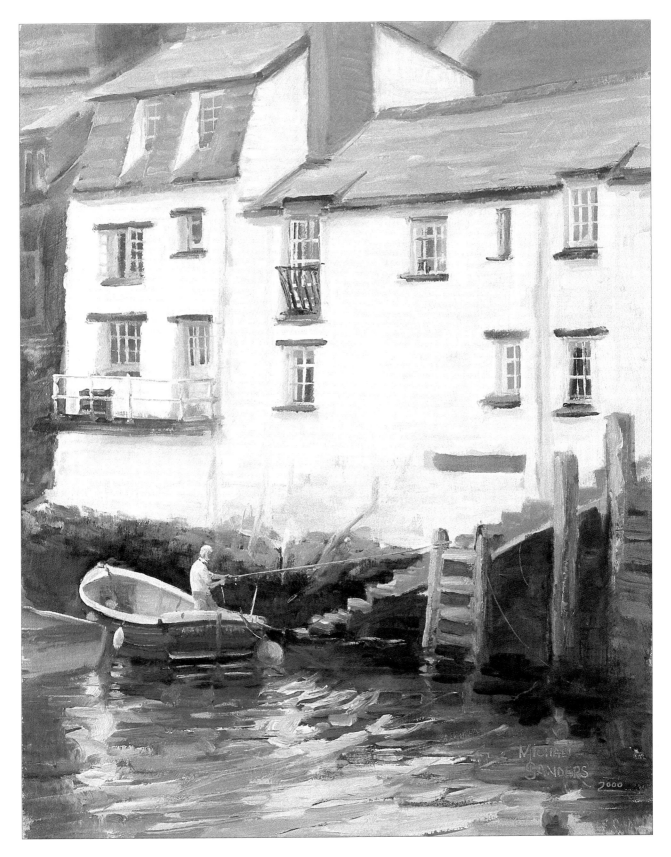

Spanish Courtyard

Knife painting is a very direct, exciting, wet on wet method of working. It pays to practise various strokes with the painting knife on a piece of primed board before attempting a painting. The application of paint is similar to spreading butter. Using the knife, spread some colour out on a large flat palette. Then scrape some paint off the palette so that you have a ridge of paint on the edge of the knife blade. With a little practice you will find that you can touch this ridge lightly on to the board and obtain a thin, crisp line of paint. Imagine masts of boats, windows, grasses, fence posts. All these can be tricky wet on wet using a brush, but are easy with a knife. Try scraping larger amounts on to the edge of the knife and applying broad, textured strokes. You can buy an *impasto* medium which I sometimes use for knife work: it stiffens the paint so that the ridges and marks show more clearly.

This knife painting evolved from a watercolour and a small figure study in pencil. As I worked on the painting, I noticed that I was making a classic mistake: I had put the focal point, the figure, exactly in the middle. This is never a good idea as it results in a static, boring composition. I should have taken my own advice and made some thumbnail sketches first, to see how the composition worked! The mistake was put right later.

You will need

Board: 3mm card primed with acrylic gesso tinted with acrylic cobalt blue

Burnt sienna

Ultramarine

Cadmium yellow deep

Cadmium yellow light

Naples yellow

Lemon yellow

Titanium white

Sap green

Phthalo blue

Permanent rose

Large and small painting knives

Cocktail stick for sgraffito

No. 4 round brush

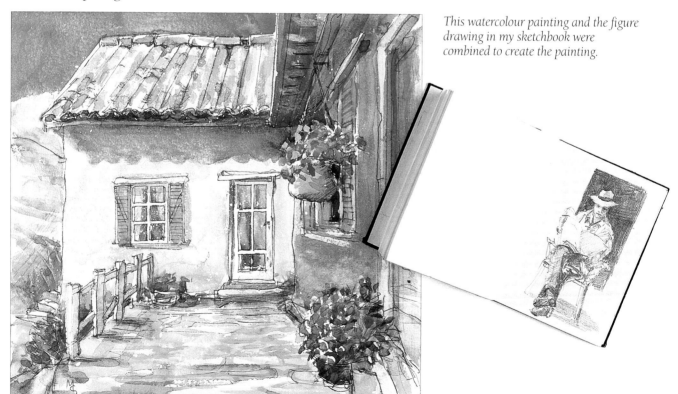

This watercolour painting and the figure drawing in my sketchbook were combined to create the painting.

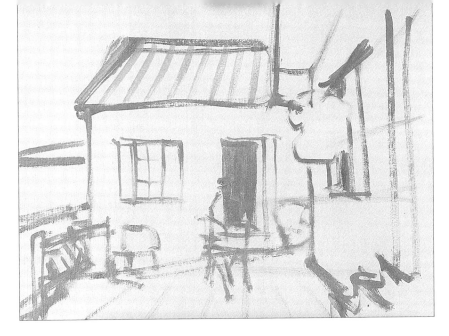

1. Sketch the building and the figure using a no. 4 round brush and a thinned mixture of burnt sienna and ultramarine.

2. Mix cadmium yellow deep with cadmium yellow light, Naples yellow and titanium white, for the roof tiles. Use a large palette knife to apply the mixture to the roof in ridges. Change the angle of the tiles to allow for perspective.

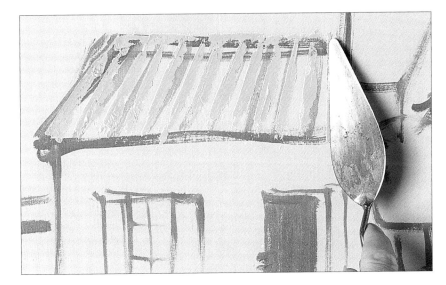

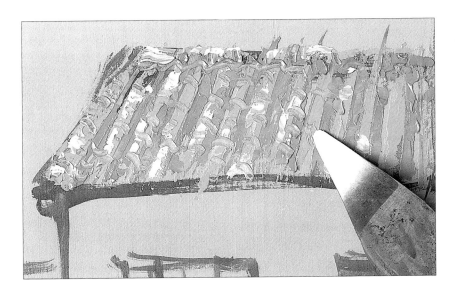

3. Modify the mix with ultramarine to make it duller for the valleys in the roof. Paint loosely and allow some background blue to show through. Add more blue to make a brownish colour for the shadows under the ridge titles. Sgraffito the angles of the tiles with the tip of the palette knife. Don't worry if the edge of the roof looks ragged – you can tidy it later when you paint the sky.

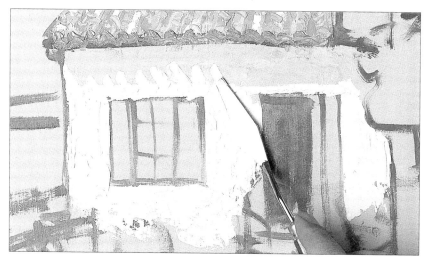

4. Use the rounded tip of the knife to put in the ends of the tiles at the edge of the roof. Mix a bluey grey from orange, ultramarine and titanium white and paint in the shadow under the roof. Paint the yellow of the house wall using cadmium yellow deep, cadmium red light, Naples yellow and white, creating a rough texture with your painting knife to suggest stucco. Change to a smaller painting knife for the detail of the edge of the roof shadow, working wet on wet. Keep the angle of the stroke the same for all the tile shadows, since this shows the direction of the sun.

5. Wipe your knife clean with paper towel. Mix ultramarine blue and burnt sienna and paint the dark of the windows. Paint the dark area inside the open door – this will make the figure stand out. Mix a pale grey for the curtains and white with a hint of grey for the window and door frames.

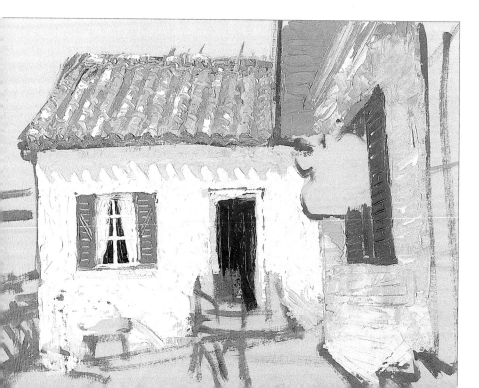

6. Paint the shutters on the left in a vibrant green mixed from sap green, lemon yellow, phthalo blue and white. Use the sgraffito technique for the lines of the shutters. Block in the dark background shadow at the top right of the painting using a mix of ultramarine and orange. As you go down the right-hand wall, lighten this mix with the orangey yellow from the first wall. The shutters on this right-hand wall should be in a darker green than the others, with more phthalo blue added.

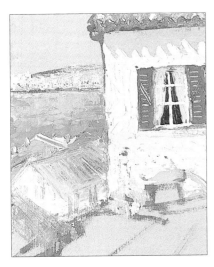
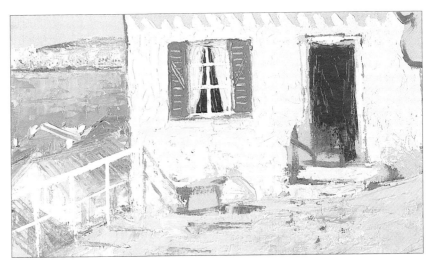

7. Paint the sea in a vivid blue mixed from phthalo blue and white with a touch of ultramarine. Mix orange with white and burnt sienna for the rooftops in the middle ground. Subdue the shade with a little pale blue for the shadows. Use the sgraffito technique to scrape back the architectural details, roof tiles and windows of these middle ground buildings. The distant land across the bay should be painted in a similar colour to the rooftops.

8. Add burnt sienna and cadmium red light to the yellow of the wall, and use it to paint the ground. Allow the blue to show through from underneath. Add suggestions of warm reds and browns to break up the monotony. Clean your large painting knife and apply titanium white with a tiny touch of Naples yellow to paint the fence. Put in the shadows of the fence posts with the edge of the knife using Naples yellow and burnt sienna.

> **Note** *At this point in the painting I decided to widen the doorway by moving the wet dark blue over to the left.*

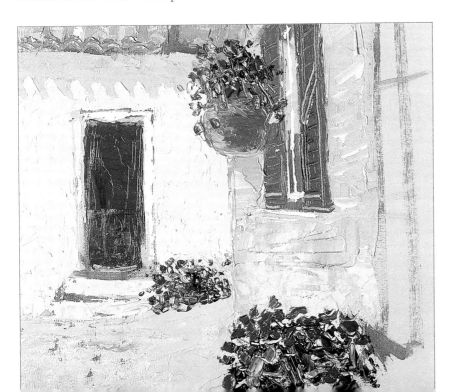

9. The terracotta of the flower tubs is a darker mix of the roof colour. Mix sap green and burnt sienna for the background green of the tubs and hanging basket. Lighten this mix with Naples yellow as required. Work wet in wet from dark to light. Touch in smaller leaves in a paler green, and darken the mix, adding less Naples yellow, for the foreground foliage. Mix the bright reds and oranges of the flowers using cadmium red light and cadmium yellow deep with a little white.

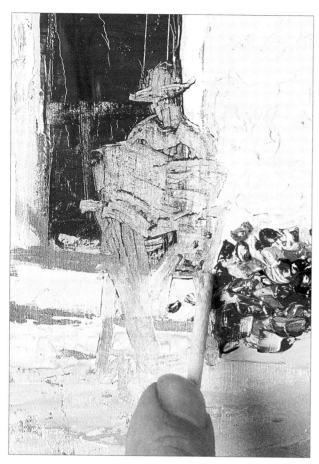

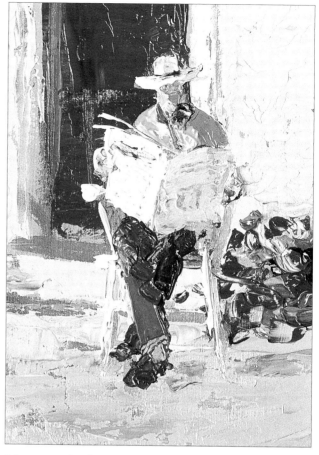

10. Scrape out the shape of the figure and his shadow using a painting knife or stick.

> **Note** *When starting on the figure, I decided to move him from the left-hand to the right-hand side of the door, since the sketch placed him bang in the middle of the composition.*

11. Paint the figure's shirt with a mix of lemon yellow and cadmium yellow deep. Darken the mix for the shadowed side. Mix burnt sienna with white and a hint of orange for the face, and burnt sienna and permanent rose for the shaded part under the figure's hat. The mix should be darker still, with more burnt sienna added, for the neck. The hand on the left should be sunlit, and the one on the right in shadow. Paint the hat in titanium white with a hint of Naples yellow, and add a little pale blue for the shaded side. Use the edge of a painting knife and titanium white to paint the edges of the newspaper's pages, and fill in the rest of the newspaper in white with a hint of blue. Mix burnt sienna with ultramarine for the darker back leg, and add Naples yellow for the lighter front leg. The feet should be little dark blobs in the same colour. Finally add a red hatband, and white highlights for the chair.

Spanish Courtyard

Size: 400 x 305mm (15¾ x 12in)

The sky, unusually for a knife painting, was added last, using a mix of ultramarine and white with a touch of phthalo blue. I would usually paint the sky first, but as the board was primed with a sky blue that was tonally close to what I wanted, I was happy to leave it until later. The warm yellow-orange of the walls works well against the blues of the sea, sky and shadows: another example of complementaries working together.

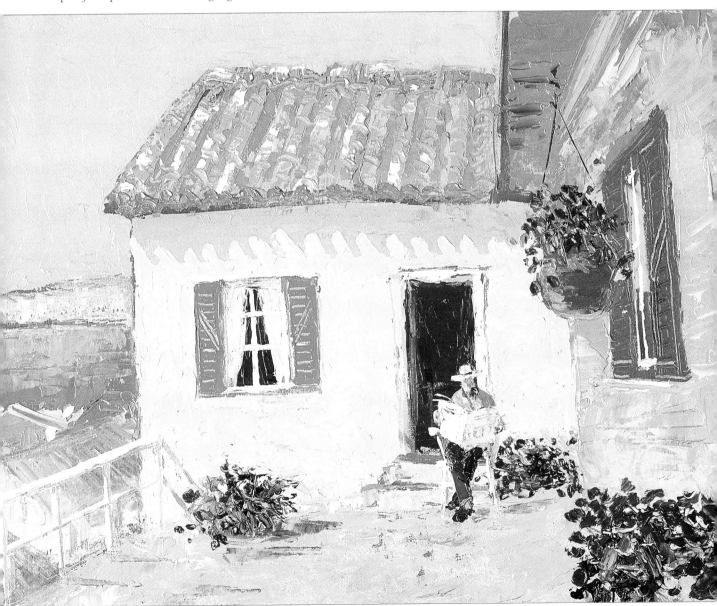

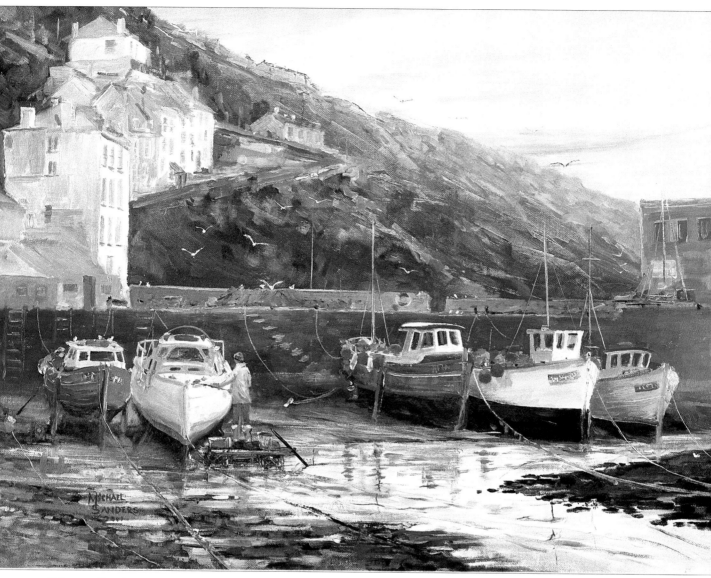

Polperro Evening
Size: 485 x 345mm (19 x 13½in)

*For me, tone gives the definition and logic to a painting; line and composition give the
dynamic or static element and colour creates the mood, the emotion. I took a gamble
in this painting by having a static, almost horizontal line through it. It works because
the line, the harbour wall, is broken by interesting colour and a couple of gaps. The
seagulls lead the eye up to the background and the sky. The colour suggests the mood
and time of day. There is a lot of strong purple, so the figure had to be yellow. Nothing
works better then complementary touches!*

Opposite

Village Gossip
Size: 355 x 485mm (14 x 19in)

*This is a composite image. The figures were lifted from my sketchbook and
arranged to form a group. I really enjoy putting the little touches into a painting
like this: the washing hanging in the doorway, the touches of red on the figures.
As with most of my work, the tonal composition is the major element, with a
strong complementary colour scheme underpinning everything.*

Index

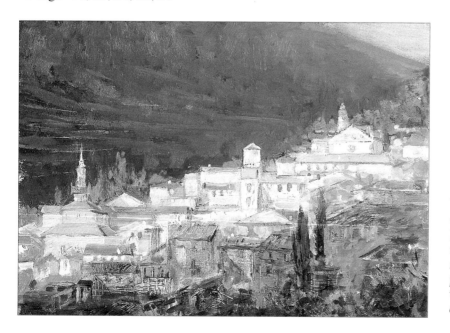

Valldemossa, Mallorca
Size: 280 x 204mm (11 x 8in)

I painted this on site, very quickly, responding to the contrast between strong light and cool shade. When the painting was dry, a pale orange glaze was applied to the buildings to accentuate the warmth.